What's Inside?

What is Zentangle®?

Zentangle is meditation achieved through pattern-drawing. A Zentangle is a complicated looking drawing that is built one line at a time. Simple tangles, or patterns, are combined in an unplanned way that grows and changes in amazing directions. With your mind engaged in drawing, your body relaxes. Anxiety and stress move to the back burner. Often, new insights are uncovered along with a sense of confidence in your creative abilities.

Zentangle was created by artists Rick Roberts and Maria Thomas as a tool to be used by artists and non-artists alike. For information about the process, instructions, and lots of beautiful examples, be sure to visit their website at **www.zentangle.com**.

Let's Get Started!

This book assumes that you are familiar with the basics of Zentangle®. But here is a quick refresher, just in case.

1. DOTS

With your pencil, make a dot in each corner of the tile. Connect the dots to make a frame.

2. STRING

Draw a pencil guideline that divides the frame into sections.

SB

Fill Patterns

3. TANGLES

Use a black 01 Pigma Micron pen (**www.sakuraofamerica.com**) to draw the tangles.

4. SHADE

5. INITIALS

And be sure to sign and date the back too.

Slurp

AURAS

Basic	**Double**
Channel	**Dark**
Perfs	**Lace**
Pearl	**Inner**

Tip: Auras are very useful around thin, subtle patterns like these swirls. The aura separates the tangle from the background, and other tangles, so it does not get lost or overpowered.

Tangles marked (ZT) are official Zentangle® patterns. Those marked (TT) are from **Totally Tangled**.

A Note on Instructions: I use a red pen to show each step of a tangle. Follow along with your black Pigma Micron pen. For example...
Step 1: draw the big and little circles.
Step 2: draw the 5 radiating lines.
Step 3: Draw the 3 circles....

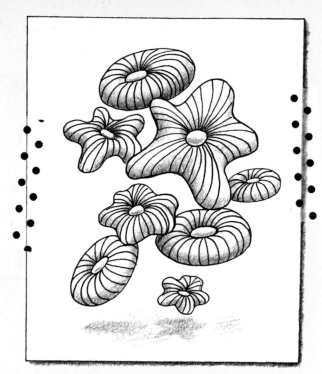

Don't be afraid to shade! Just like learning to tangle, it takes some practice. You don't have to worry about "real" shadows - reflected shadows, cast shadows and all that artsy stuff. But there are some cool tricks that can help your designs look more rounded and 3-D.

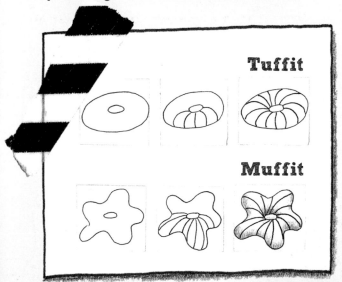

Tuffit

Muffit

Get comfortable with your pencil:

Hold it upright to make a line (string).

Draw lots of swirls and squiggles.

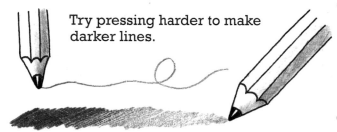

Try pressing harder to make darker lines.

Next, using the side of your pencil, try pressing as hard as you can to make a black (dark gray) swatch. As you scribble back and forth, lessen the pressure, little by little.

Now you have lighter gray swatches too. Try to make an even blend that goes from black to very pale gray. Rather like a gray rainbow.

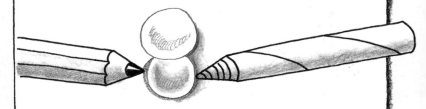

Draw a shape (ie: a circle) and outline it again in pencil. Use your finger or a paper blending stump to smudge the pencil.

Blend back and forth and slowly spread the gray out onto the white paper.

Flat Shading

Here are some tricks for shading flat surfaces.

1. LAYERS

Add a bit of shadow under the bottom edges.

A crisp shadow makes it look like the objects are close to the surface.

2. CUT OUTS

A smudged shadow lifts the object higher off the surface.

5. CUBED

Shade one very dark side, one light gray side and one side stays white.

3. OVERLAP

Just a little shading on either side.

4. GROUND

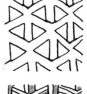

A smudge of shadow at the base of the object suggests a floor.

6. SHINE

light on the "hills"

Dark in the "valleys"

Etcher

A black background adds a lot of depth. The contrast makes the lighter objects pop out.

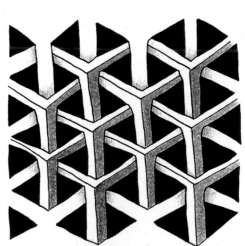

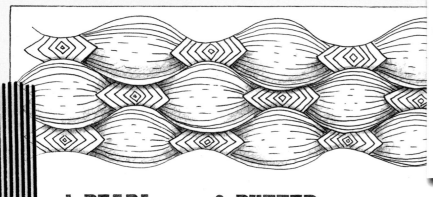

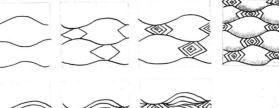

1. PEARL

Use a "smiley face," or crescent, of shading. Smudge in a circle.

2. PUFFED

Smudge shadow along the bottom edge.

3. GRADATION

Shade the bottom edge, then blend upwards.

4. PRESSED

Shade the top edge. Smudge downwards.

Really flat, boring

Roundness created by lines only

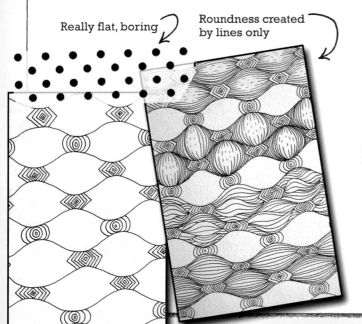

Round Shading

Make tangles look "round" with these tricks:

Curved, horizontal lines with highlights caused by broken lines ↗

Crescent moon or "pearl" shading ↘

Curved vertical lines give a bulging look. →

Wavy striped lines ↘

Shading under the edge creates layering. ↘

Curved horizontal lines. Compare this with the first sample. ↗

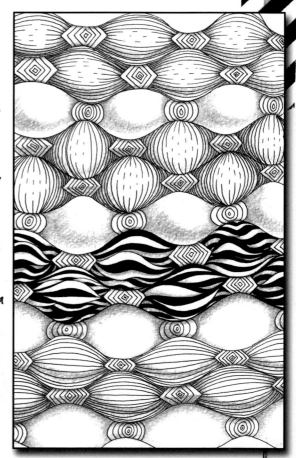

Love Your Curves

Tide

 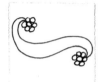 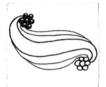

These tangles are nice and *curvy* just as they are.

Tideberry

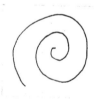 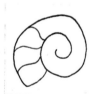 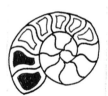 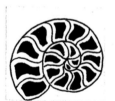

But do you notice how a bit of shading gives *Tideberry* a lot more roundness and dimension?

Ammon

 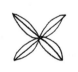 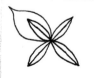 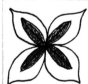

I did not shade *Ammon* because I wanted it to look like the flat side of a cut fossil.

Tip: The gray of your pencil can serve as a third color too.

Pixie

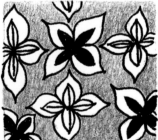

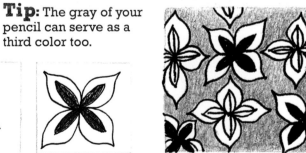

Slink

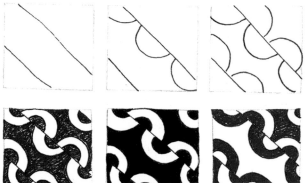

Y.A.F. (Yet Another Flower)

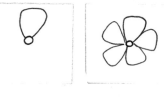
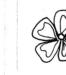

Gewgle

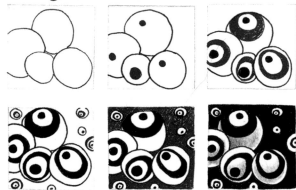
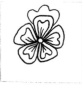
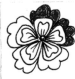
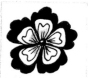

Exercise: Try drawing each of these tangles using a different type of shading.

For example, can you make *Slink* look shiny?

What happens to *Gewgle* or *Circfleur* if you use layered shading rather than pearl?

How could you make *Radia* look rounded?

Radia

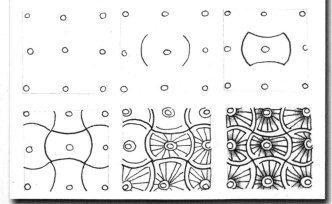

Circfleur

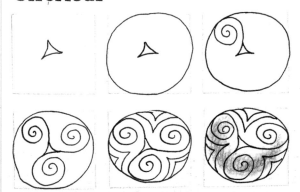

Box It

Florgrate

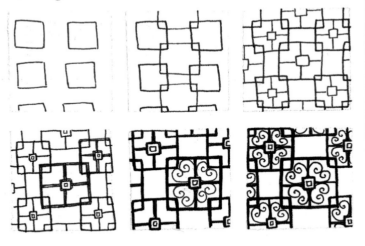

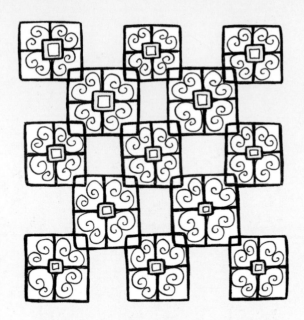

The variety of tangles that can be created by starting with a simple grid... *unlimited!*

Boxt

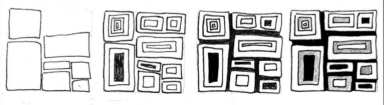

Boxt and *Krust* are very similar - the differences are subtle. *Krust* has rounded corners and round shading. *Boxt* is flat and graphic - the gray is only used as color.

Krust

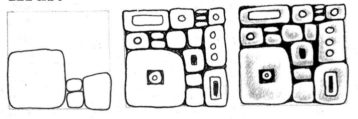

Pi (with variations)

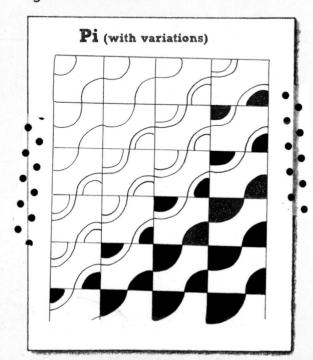

Ninja

 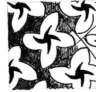 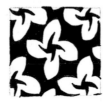

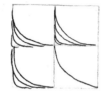

Cootie

(It looks like a "cootie catcher"!)

Fürn

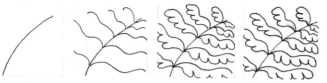

Zusafürn

Draw the design, THEN the grid.

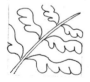

Subcub

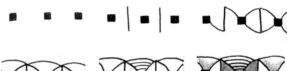

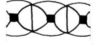 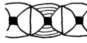

Tentacle

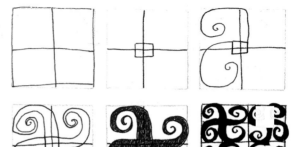

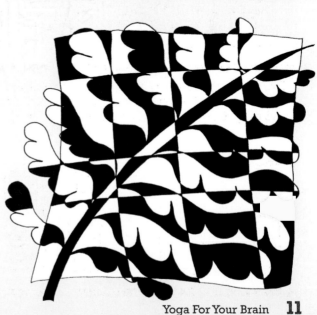

Ballenchain

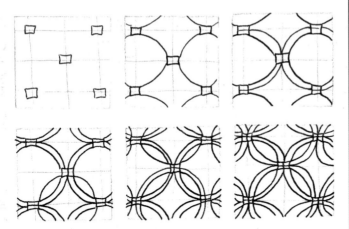

Break It Down

I love deconstructing patterns. For me, it's like a game or puzzle. How can I draw a design in six steps or less?

Ballenchain was inspired by an image of a quilt in a catalog. The pattern was called "Wedding Ring" and looked... *impossible*! Yeah! Bring it on. As I stared at the quilt, a grid emerged running through the little squares. The rest of the design fell into place once I found the grid. The chains are composed of arcs (1/4 of a circle), each attached to 1/4 of each little square.

My sketch (below) shows the progression. I use pencil to sketch as I am deconstructing. A grid is also useful for drawing this tangle. It can be erased after, or hidden by shading in the background with pencil or pen.

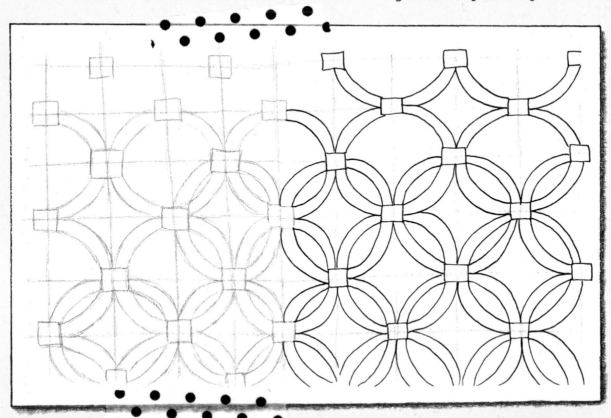

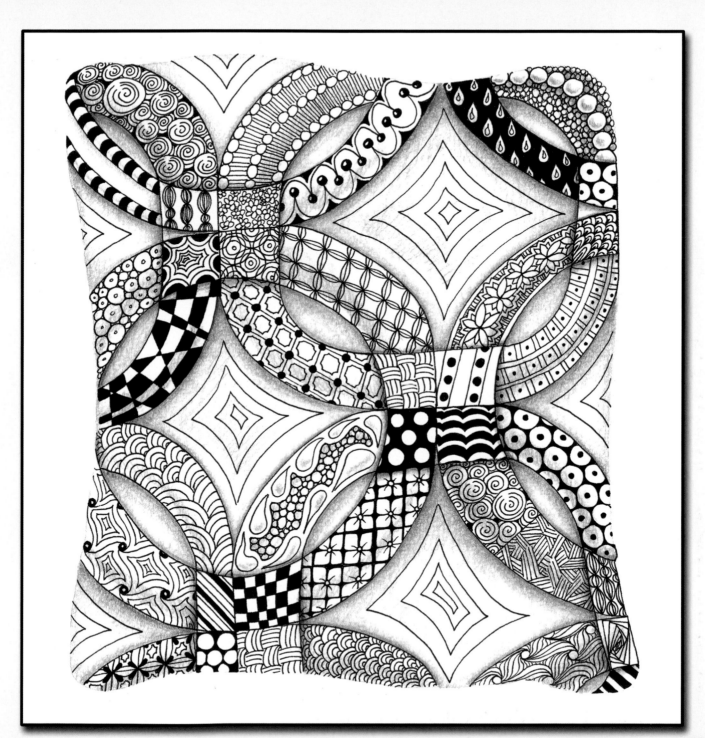

Big Moves

By super-sizing your tangle, it serves as the tangle and the string, all in one. Stretch it!

This is good practice for loosening up. We tend to grip the pen too tightly after drawing for a while and the designs get smaller and smaller. I find that I even hold my breath sometimes.

Sit up straight.
Shake out your hands.
Hold the pen gently.
Now breathe –
and draw big!

Exercise: Draw your favorite tangle... BIG! The more complex the pattern, the more fun it is to fill it with other tangles.

On the previous page, I blew up *Ballenchain* and filled each section with more patterns. This crazy quilt of an image is reminiscent of its fabric origins.

Bellaposa

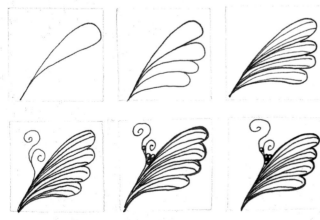

Paisley

Paisley Passion

 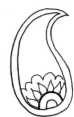 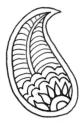

The paisley starts as a curved teardrop.

Grow the design from the bottom up.

Wrap another pattern, or an aura, around the outside too.

Paisleys grow, one step at a time, rather like a Zentangle… or a zendala (see page 17). But paisleys don't need to be symmetrical. And the tails lend themselves to spontaneous flourishes and embellishments!

Repeat your paisley design to fill an area, as a tangle. Or blow it up and use it as the string.

A paisley looks sophisticated even when filled with just one simple pattern…

Or two patterns!

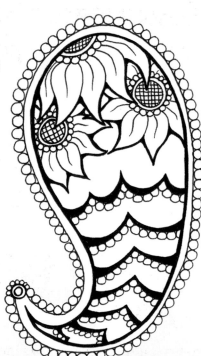

Running in (Big) Circles

Flores DeCasa

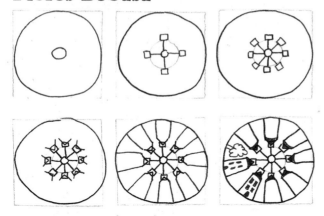

As a baby, my first home was an apartment in Guam, called "Casa de Flores." *The House of Flowers.*
This tangle is a "Flower of Houses."

I had been trying to create a new tangle based on a ceiling fan and it looked terrible. Failure.
Wait a minute... if I add a door... and a roof...
Trees and shrubbery disguise my uneven spacing!

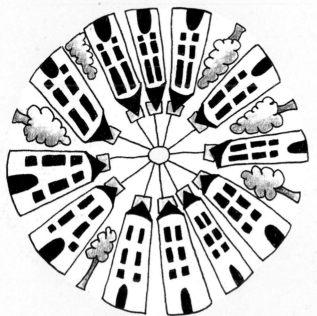

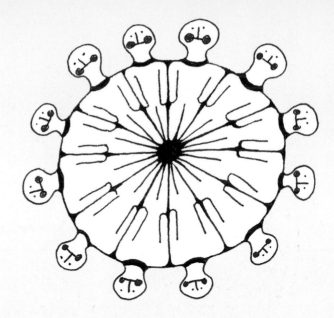

While adventuring in Alaska (ok, I was actually shopping), I was charmed by these little good luck tokens carved from whale bone. And if one is lucky, why not draw a whole team of them?

Exercise: Draw *Billiken* big and fill his (her?) bodies with different tangles. Or use Billiken as the center of a zendala. How would you work your way out... maybe with different hairstyles? Hmmm...

Billiken

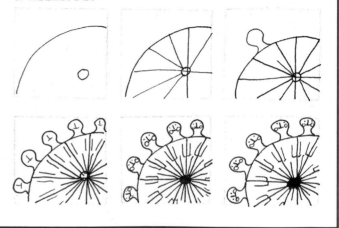

Mumsy

 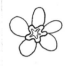 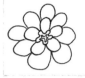 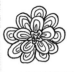

Zendalas Revisited

Zentangles drawn in a circle. Seems like a no-brainer. Any tangle can be wrapped around any other tangle. But have you noticed how many flower motifs are appearing as tangles? Flowers are nature's zendalas. They build out from a center point, going around and around...

Exercise: Take your favorite flower tangle and enlarge it. Now try wrapping other tangles and auras around it.

Crescent Moons (ZT) also love to play with zendalas. If you ever feel stuck while building your zendala, add a ring of *crescent moons* (see right). They will jumpstart your ideas and get you drawing again.

Other tangles like to grow from the crevices.

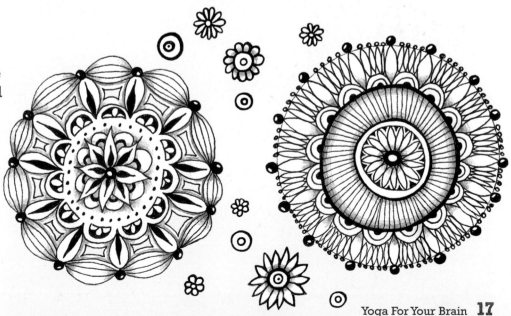

Chill Out

Baseflake

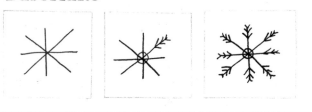

Flake

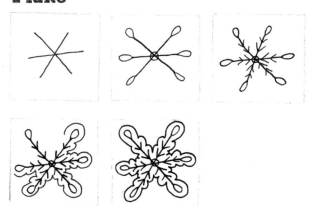

Crystle

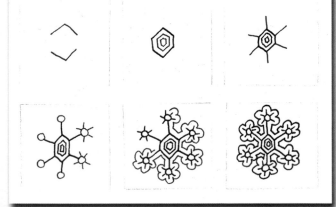

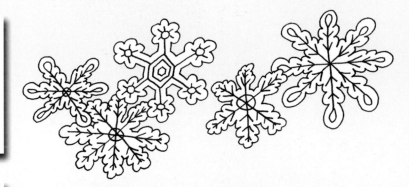

Here's a little cool down before we get to the more strenuous brain workout!

Snowflakes make really pretty filler tangles. But if you have been paying attention to the last few pages, you are probably thinking "Blow it up!"

Enlarged

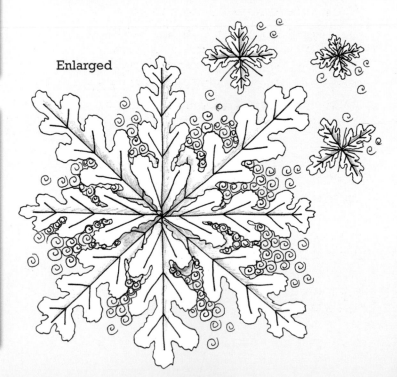

Zenflakes

Big snowflakes filled with tangles?
Zenflakes, of course!? (I considered
"snowtangles." But, no, that sounds more
like a tangle drawn in the snow...)
To express your inner flake, draw a large
asterisk shape ✳ then wrap, or build, your
tangles around the arms. The asterisk
serves as your string. But instead of filling
IN your tangles, you fill them OUT.

This zenflake (left) is *Quabog (ZT)*
wrapped around a *Baseflake.*

The zenflake on the left page was
created from a classic tangle named
Sampson (ZT). I just superimposed
the leaves onto the arms of *Baseflake.*
I drew four leaves in front and four in
back. I left four arms exposed on the
teeny flakes.

Exercise: Put your new moves together.
Combine a Zenflake with a Zendala and
then... supersize it.

If you come up with a name for that, let me
know. I'm at a loss... maybe a "Flakedala"?

My flakedala (no, that's not going to work!)
has a Pennsylvania Dutch look to it! (right)

Working It Out
On the Go

Take your journal with you when you leave the house.

Vine

Twist

With complicated designs, it often helps to first draw the negative space - the background shapes. I squinted hard at the intertwining pattern on a staircase, until I saw only the repeating almond shapes and little circles. Once I had achieved the basic shape of the design, it was easy to add the curving detail lines that give Uptown it's sinuous look.

Uptown

The photos on these two pages were all taken at Old Sturbridge Village in Massachusetts. You never know where you will see wonderful patterns!

Inspiration is everywhere!

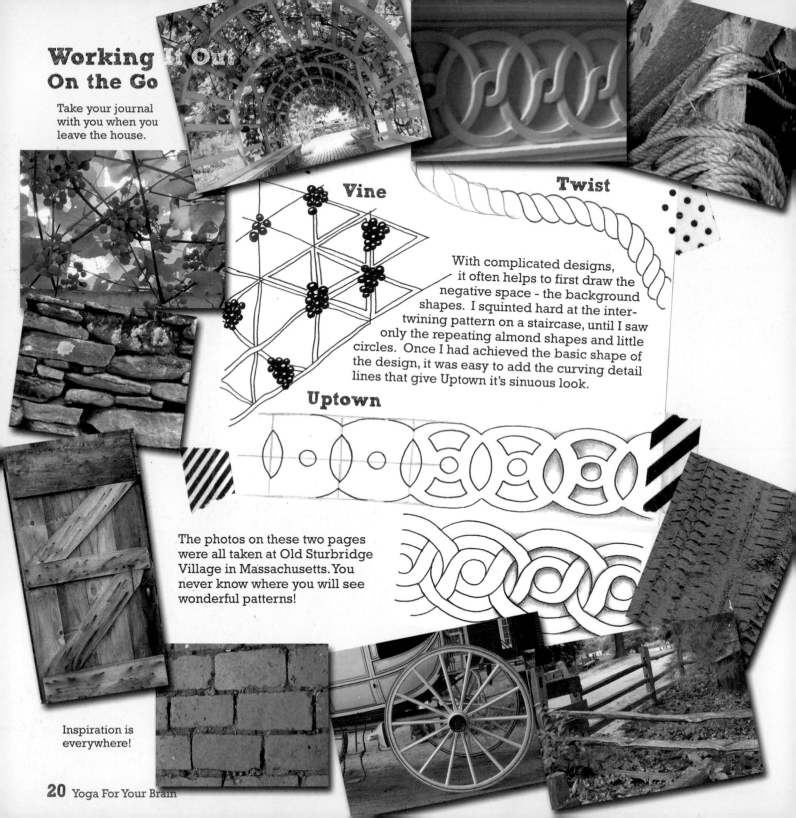

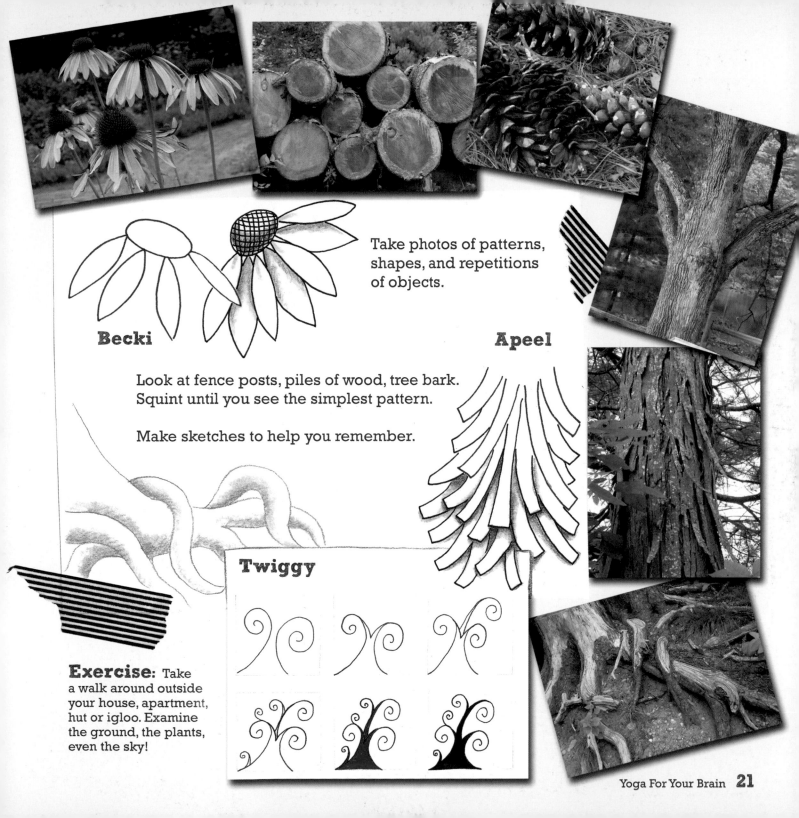

Take photos of patterns, shapes, and repetitions of objects.

Becki

Apeel

Look at fence posts, piles of wood, tree bark. Squint until you see the simplest pattern.

Make sketches to help you remember.

Twiggy

Exercise: Take a walk around outside your house, apartment, hut or igloo. Examine the ground, the plants, even the sky!

Every night, when I travel, I print out some choice photos on my little Polaroid POGO printer (**www.polaroid.com**). I stick the teeny pictures into my journal as writing prompts. Many of the pictures are actually interesting textures and patterns I stumble across. Later, I go through the journal and draw all my favorites.

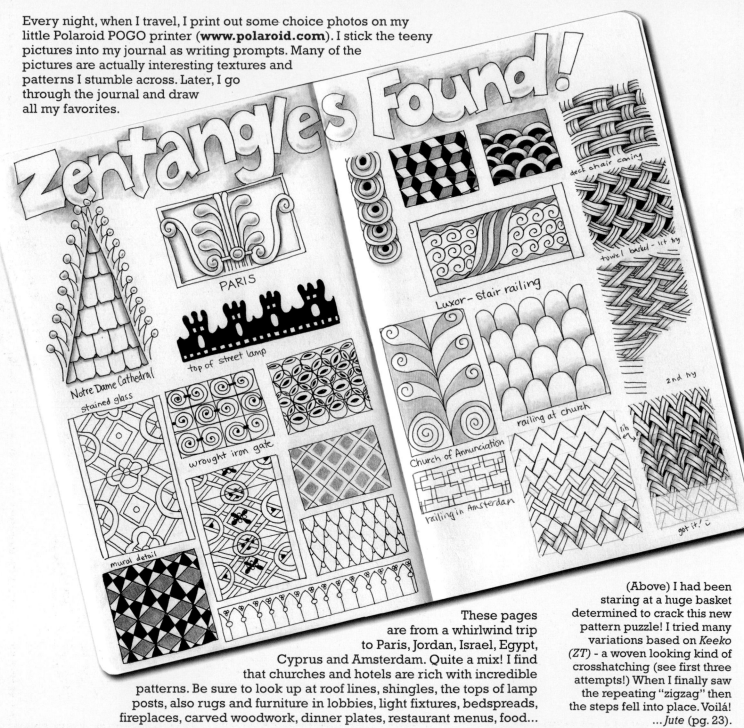

Zentangles Found!!

PARIS

Notre Dame Cathedral stained glass

top of street lamp

wrought iron gate

mural detail

deck chair caning

towel basket - 1st try

2nd try

got it! ☺

Luxor - stair railing

railing at church

Church of Annunciation

railing in Amsterdam

rib

These pages are from a whirlwind trip to Paris, Jordan, Israel, Egypt, Cyprus and Amsterdam. Quite a mix! I find that churches and hotels are rich with incredible patterns. Be sure to look up at roof lines, shingles, the tops of lamp posts, also rugs and furniture in lobbies, light fixtures, bedspreads, fireplaces, carved woodwork, dinner plates, restaurant menus, food...

(Above) I had been staring at a huge basket determined to crack this new pattern puzzle! I tried many variations based on *Keeko* (*ZT*) - a woven looking kind of crosshatching (see first three attempts!) When I finally saw the repeating "zigzag" then the steps fell into place. Voilá! ...*Jute* (pg. 23).

X-glass

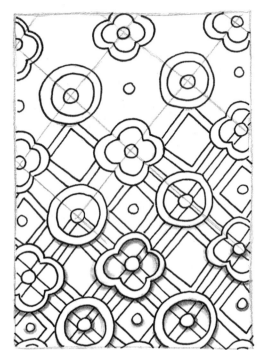

- start with a pencil grid

- draw small circles on all the intersections

- draw larger circles on every other intersection

- draw flower shapes on the remaining inter-sections

- draw diamond shapes to connect two circles to two flowers

- draw lines along the grid to connect all the smaller circles. These lines go "under" the big circles and flowers.

X-glass is based on a stained glass window in Notre Dame Cathedral (see sketch on far left of journal page).

Jute

Exercise: Round off the ends of the woven strips and the reeds change from flat to rounded! Notice how the slight change in shading alters the illusion as well?

Lustrade (inspired by a fancy railing in Jordan)

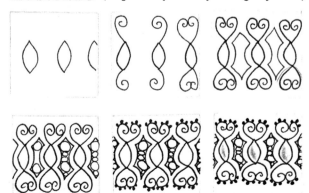

How does the different shading affect the two versions of *Itch*, below?

Itch (carved into a stone wall in Paris)

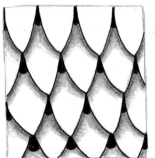

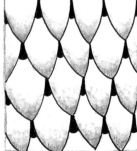

Pellet

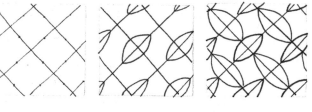

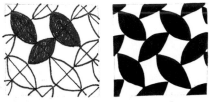

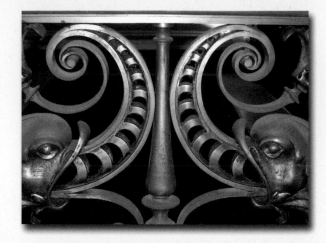

Tip: Try making the almond shapes longer and thinner for a different look. Or leave a little space at the end of each shape.

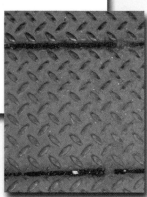

Tung

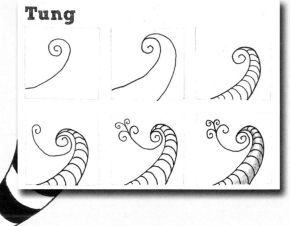

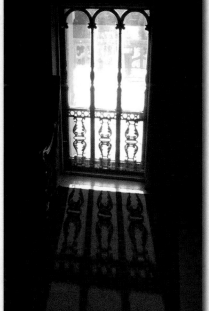

Lustrade (pg. 23) was also inspired by this photo (left).

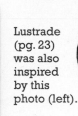

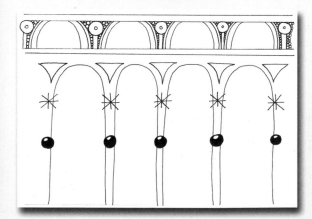

This *Columns* tangle is a combination of the photo at left, and the little sketch at the bottom left of my journal page (pg. 22). It is really just a reversed *Crescent Moon* variation.

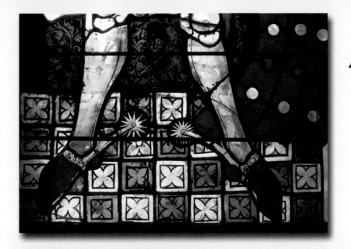

Chads

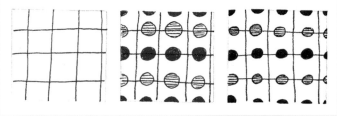

Bingley

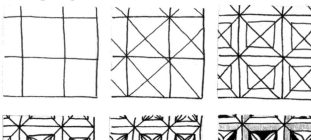

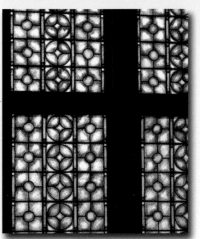

Purlbox is a combination of *Chads* and *Bingley*. You could draw *Purlbox* without the lines between the pearls. The line gives the illusion that the pearls are strung together.

Exercise: Switch the shading around in *Purlbox*. Color the section *beneath* each pearl black. The pearls will appear to be on top of a mountain rather than inside a box.

Botto

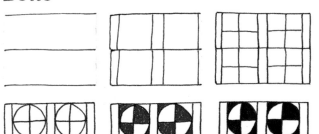

Purlbox

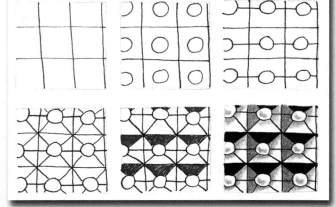

Annee

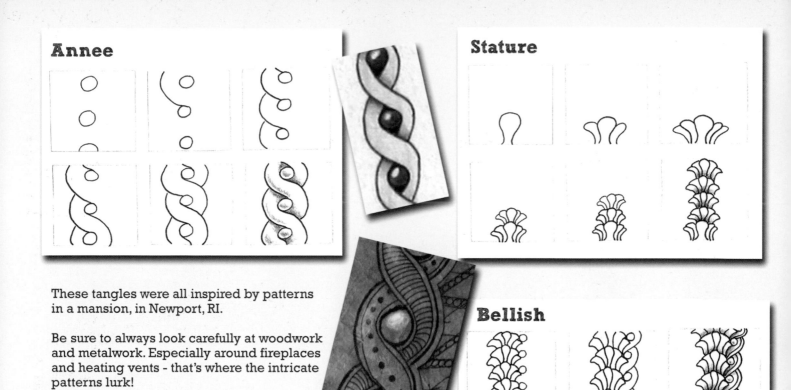

Stature

These tangles were all inspired by patterns in a mansion, in Newport, RI.

Be sure to always look carefully at woodwork and metalwork. Especially around fireplaces and heating vents - that's where the intricate patterns lurk!

Exercise: Combine all four of these tangles together!

Bellish

Kringel

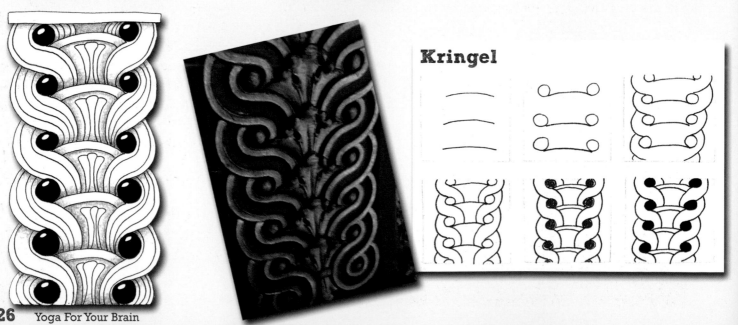

Fleur

HExffleur

Fleur-ish

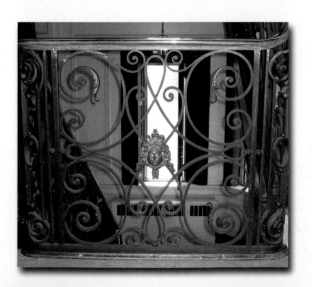

The beautiful, calligraphic flourishes found in railings and other metalwork can be very intimidating.
Relax.
Squint.
Scan for an easy, basic shape - such as a diamond or a square. Start with that shape and build onto it. Then look for lines and shapes that are mirrored around your first shape.

These flourishes would also be intriguing, enlarged, and used as your string.

Tangled Women

Caral

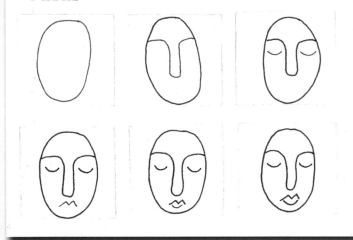

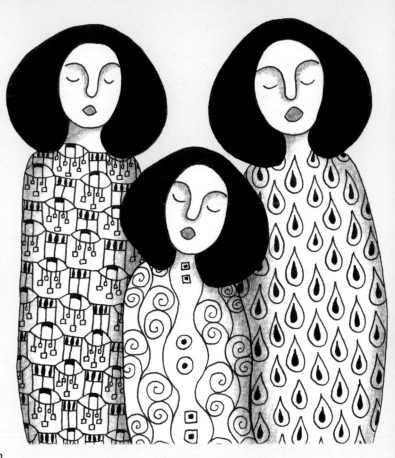

I managed to make it through years of art history classes without actually learning anything. The lights went down, the slides went up on the screen... and I fell asleep.

So imagine my delight when I recently re-discovered the artist Gustav Klimt. The women's faces and arms were painted true to life. But the clothing and backgrounds were flattened and filled with designs. Klimt literally submerged his subjects in Zentangle-like patterns. And lots of gold paint!

People are no harder to draw than any other tangle. *Caral* and *Portia* give you two basic ways to create a face, as a tangle. Hair can be very simple. Arms and legs are highly overrated.

Portia

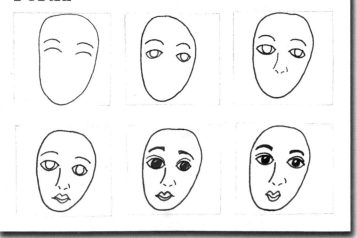

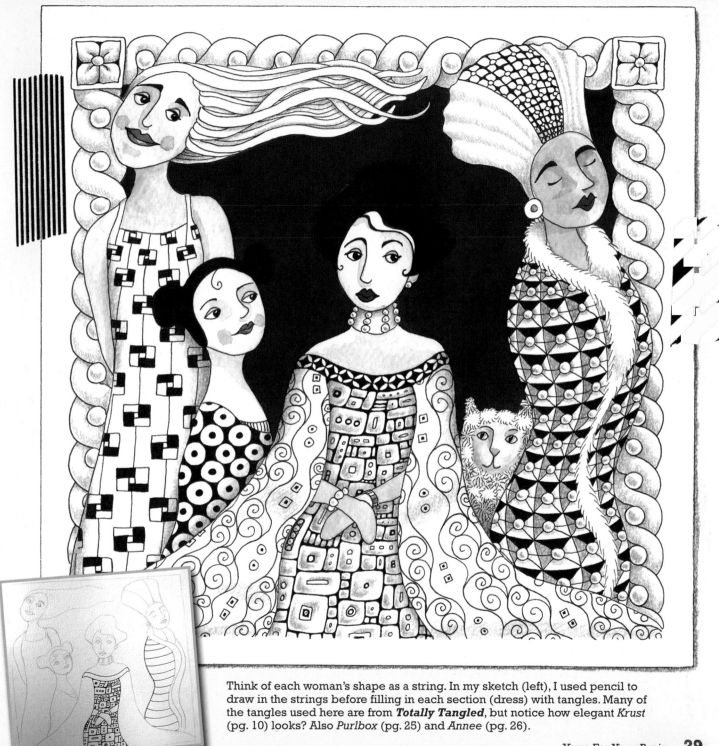

Think of each woman's shape as a string. In my sketch (left), I used pencil to draw in the strings before filling in each section (dress) with tangles. Many of the tangles used here are from **Totally Tangled**, but notice how elegant *Krust* (pg. 10) looks? Also *Purlbox* (pg. 25) and *Annee* (pg. 26).

Switch it Up

VARIATIONS & COMBINATIONS

The simplest way to create new tangles is to work off of an old tangle. Perhaps you have already discovered that, while drawing a tangle, a new design appears? What happens if you change any one element of a design?

Ogel

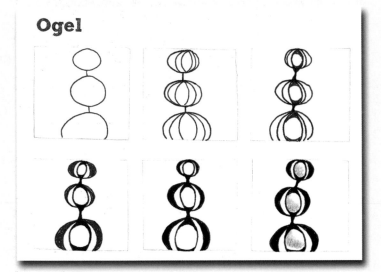

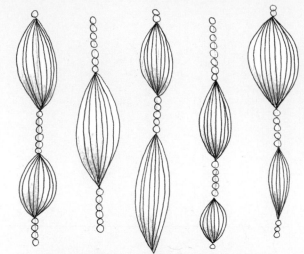

This tangle, *Ramykin*, is based on *Ramy (TT)*, but the beads were pulled apart and tiny pearls added between.

Ogel started out as *Punkin (TT)* (steps one and two). But instead of starting *Punkin* with a straight, vertical line, I drew the round shapes first, then connected each with a short line. Oops! But I kept going, drawing in the curves of the pumpkin shapes. The missing center line created an opening that looked very pod-like to me. So I added a "pea." When I colored in the little bit of pod behind each pea, I extended the black out onto the connecting line. It looked a bit drippy. The string on the far right looked rather like staring eyes (hence the name "ogle/ogel"). They also looked the most similar to *Punkin*. The design changes dramatically by simply coloring in some of the stripes.

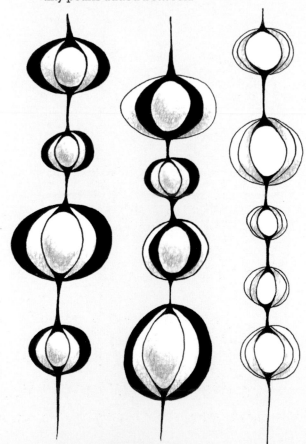

Quip

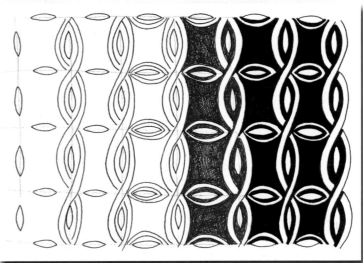

Quip is based on *Bales (ZT)*, with some inspiration from *Annee* (pg. 26) thrown in. *Annee* wraps the braid-like strips around each circle. *Quip* wraps them around each almond shape. These strips form a sort of aura around the almonds.

Exercise: Draw *Quip* without using the auras. Wrap the braid-like strips right up to the almond shapes.

Turn the design 90 degrees and wrap strips around the almond shapes in this direction as well.

Try coloring in the almond shapes as well as the background.

Bales is the ultimate Zentangle! It is a very simple design to draw, and yet the variations possible are infinite.

Bales (ZT)

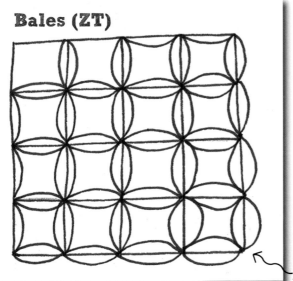

puffed!

Exercise: Fill an entire page with variations on *Bales*.

Try auras, shading, dots, color in half of each shape, backgrounds... Try "puffing" each almond shape.

Now think inside the box... draw the almond shapes inside each square, instead of on the lines. Try them diagonally, all in the same direction, alternating, zig zagged...

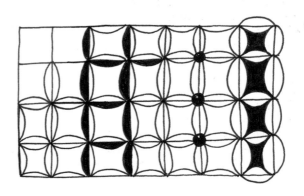

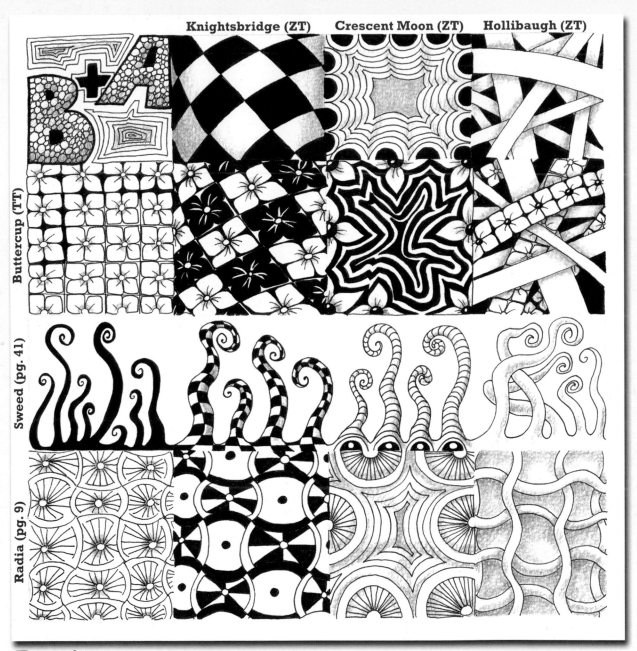

Knightsbridge (ZT) Crescent Moon (ZT) Hollibaugh (ZT)

Buttercup (TT)

Sweed (pg. 41)

Radia (pg. 9)

Exercise: Divide your paper into 16 squares. Leave the top left square empty. Put a basic tangle into each of the top three squares and three tangles you use a lot (or never!) into the three squares along the left edge. Now combine each row and column to create new tangles. For example, when I combined *Sweed* (row 3) with *Knightsbridge* (column 1), I chose to wrap the checkerboard around the the tendrils themselves. What other options are there?

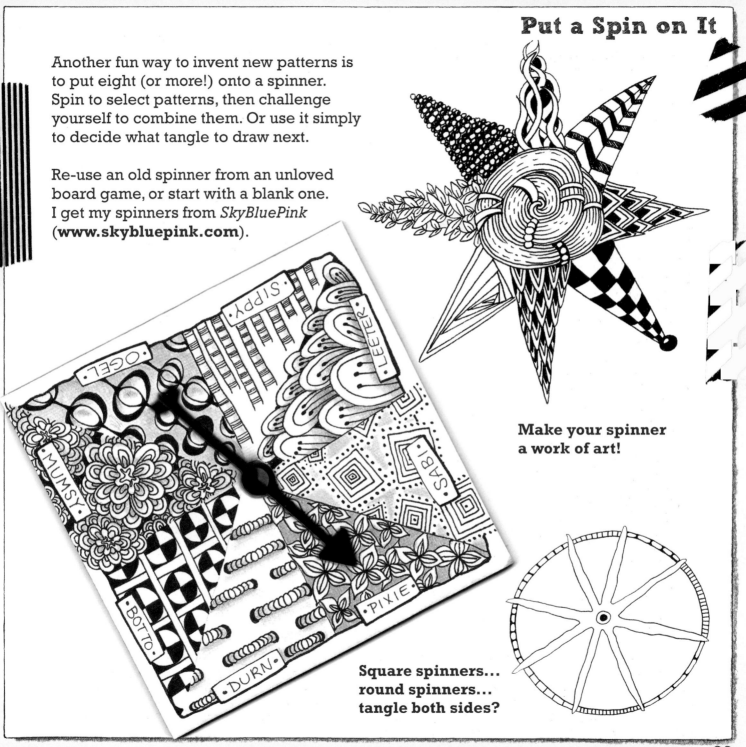

Another fun way to invent new patterns is to put eight (or more!) onto a spinner. Spin to select patterns, then challenge yourself to combine them. Or use it simply to decide what tangle to draw next.

Re-use an old spinner from an unloved board game, or start with a blank one. I get my spinners from *SkyBluePink* (**www.skybluepink.com**).

Put a Spin on It

Make your spinner
a work of art!

Square spinners...
round spinners...
tangle both sides?

Braintangling

I'm not a multi-tasker. Maybe you aren't either? I'd love to be one, but I can't focus on a lot of things at once. That is probably why Zentangle works so well for me - when I am drawing and dissecting patterns, I can't concentrate on my worries.

I AM a listmaker and a mindmapper though. Mindmapping is a way to sort out your thoughts and "to-do" lists. Typically, you start by drawing a circle or box at the center of your paper to represent you or the main thought or problem that you are sorting out. Then, draw lines off of the circle connecting to other boxes or circles with "sub-thoughts." There can be more lines and boxes branching off of these, or just make little lists under each subheading.

Listmaking and mind-mapping both combine nicely with Zentangle to sort thoughts and to brainstorm.

Combine them with Zendalas and spinners...

1. **Start with a circle.**
2. **Divide it into equal sections.**
3. **Label each section with a concern or idea.**
4. **Start tangling around the circle.**
5. **Pay attention to your thoughts as you draw.**
6. **Jot each topic into a section as it pops into your head.**
7. **Keep tangling and writing in the thoughts as they pop up.**

Tangle until your brain feels lighter.

This braintangle could be at the center of an elaborate Zendala!

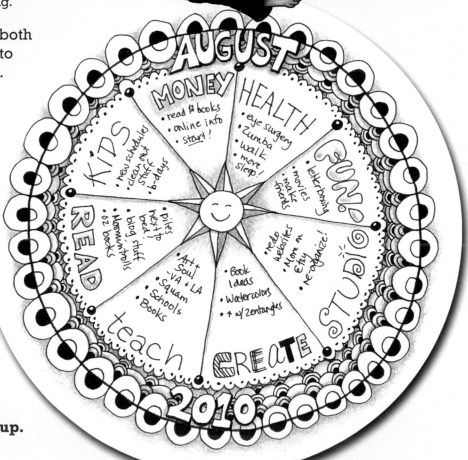

Wabi

Sabi

Try braintangling a particular problem or challenge. Place the problem to solve, or mull over, in the center and tangle outwards. As ideas pop into your mind, integrate them into the Zentangle/braintangle web.

If you have trouble with meditation or prayer, use braintangling to stay focused.

For example: let's say you have a friend who is sick and you would like to pray for them or send them positive, healing thoughts, but you find that other distractions keep entering your mind and you feel guilty for not concentrating solely on your sick friend.

Put the friend's name or their image in the center of the page.
(Try a transfer of a photo! See pg. 40)

Start tangling around it. As you think of your wishes for the friend, write or draw them into the tangle.

If you find your thoughts straying, simply focus back on the central image or name, and continue.

When you finish, you have a visible reminder of your prayer.

What Do You Love?

My tangle passions lean towards Egyptian and Mehndi patterns, swirls, stripes, 3-D and whimsical designs. And tentacles.

I have tried to do more sophisticated, elegant Zentangles, but I can't help adding something silly!

If you have been fortunate enough to have taken a Zentangle class, you will have seen how different everyones' tiles are. Every student learns the same four, or so, basic tangles. They all hear the same directions. But when all the tiles are put together in a little mosaic... WOW! They are all so different! Personal style is a GOOD thing. The more Zentangles you create, the more your style evolves and develops. Your preferences for darker or lighter lines, graphic or organic tangles, color or shading, size and complexity... these all make your Zentangles unique, your own signature.

Pingline

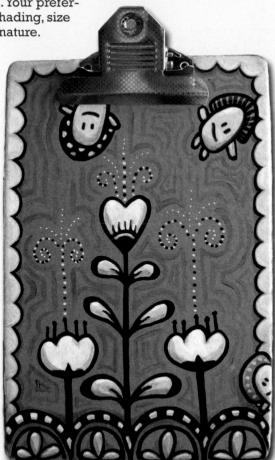

I made this teeny clipboard for my friend Shelly to use during chemotherapy and long waits for doctor appointments. It is just big enough to support a tile, and her hand, as she draws.

I used Sharpie Oil-based paint markers (**www. dickblick.com**) for the *Crescent Moon (ZT)*, *Lilah Bean (TT)*, *Jacki (TT)* and *Yawn (TT)* tangles.

Notice all the different types of "auras"?

Wingding

Durn

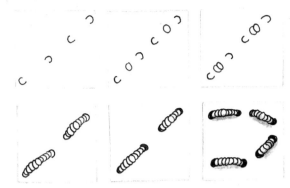

So, what are your passions and interests?

Do you love fabric or quilting? Lots of inspiring patterns there! Books, plants, cooking, horses, fish... ?

Look at the patterns created by a collection of items as well as the patterns carved or printed onto them.

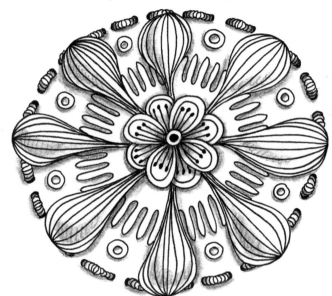

Whysk

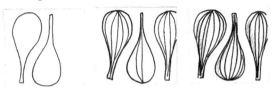

Sporktine

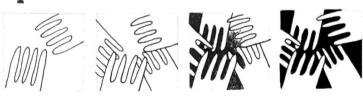

A zendala made from kitchen utensils!

Every profession or hobby has something that could be turned into a tangle. Yes, even accounting!

Leeter

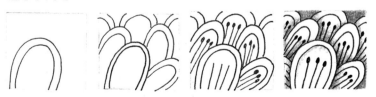

Leeter was inspired by a strange electric mixer-attachment-thingy. But when I had drawn a whole bunch of them, they started to look more like three-eyed aliens (!?) ("Take me to your leader!") Did I mention that I can't help being a little silly?

What you love applies to style, too, not just subject matter - although they often are intertwined. If you like ornate, whimsical, sophisticated, geometric, country or folk art style... add it to your Zentangles. Analyze the style that you like, the same way you might analyze a pattern you are trying to break down into steps. Squint if it helps!

Country or Primitive style is not something I am very familiar with, so I chose it as an example. As I looked at samples in magazines, I noticed chickens, cats and sunflowers as recurring themes. As for style... the lines seemed more timid, a bit shaky, worn down. Perfection is a bad thing. Here I found raw edges and unraveling bits of cloth. Quite a challenge.

I found that drawing faster helped. I puffed up the *Printemps (ZT)* spirals in the background and left off the highlights. (Country style is not very "shiny"). The sunflowers are just large *Crescent Moons (ZT)* with a shaggy, sunburst-like aura. And the frame is composed of *Sippy* (pg. 39) but I wiggled it a bit so it looks like birch bark.

There isn't a lot of contrast in the country look, but I felt the cat's face got lost in the background, so I couldn't help but add a bit of my own style!

Besochix

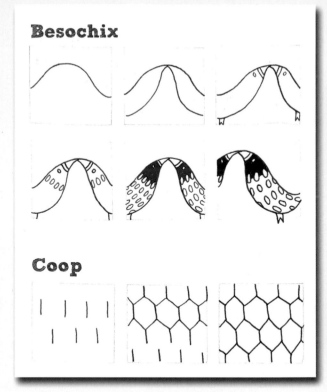

Coop

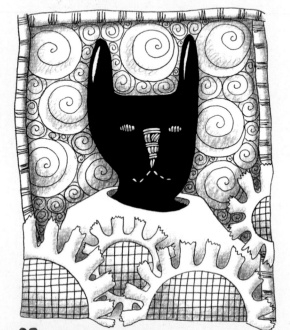

Notice the aura around my kissing chicks? It helps them stand out from the background. The shading also helps push the *Coop* pattern back.

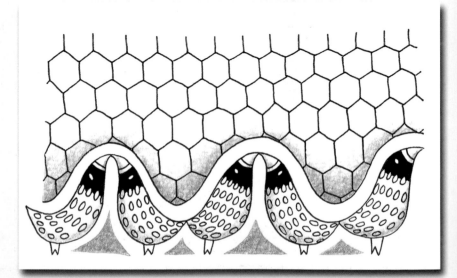

This design still has some of the primitive style, but the lines are bolder and a bit more cartoon-like. This is a bit more MY style - swirly and silly - and a teeny bit creepy?

Look at your Zentangles. Are your lines dark and strong, or shaky and thin? Do you prefer flowers and vines or grids and 3-D tangles? Do you only tangle in circles? Triangles? Bird shapes? Embrace your style!

If you have seen Maria Thomas' artwork on **www.zentangle.com** or on her studio site (**www.mariathomasonline.com**) - her art is full of flourishes and depth and plants. She pours her passion for calligraphy and botanical illustration into her Zentangles. Rick Roberts' Zentangles are all about math, science and the golden mean!

What do your tangles say about you?

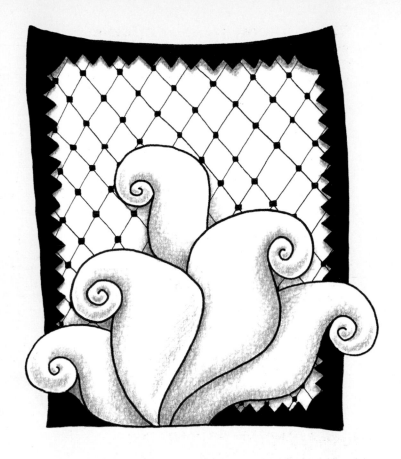

Fidget

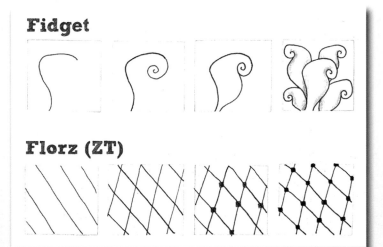

Florz (ZT)

This tangle is named in honor of our babysitter's cat, Fidget, who has no tail!

Sippy would look completely different with solid black stripes. The scratchy lines give it a thinner, more transparent feel.

Sippy

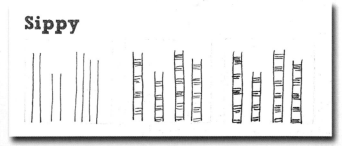

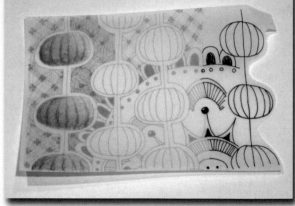

1.-2.

Transfers

Do your experiences with making transfers involve gel medium, packing tape or water-slide decals? My own experiences were always messy, lumpy, and generally disappointing. Sheer Heaven (**www.cre8it.com**) will change your life. This unrip-able, semi-transparent, art paper (with a smooth side and a toothy side) was designed to use with colored pencils, chalks and pastels with no need for fixative. That Sheer Heaven makes beautiful transfers, was discovered accidentally!

1. Print clip art, photos or scans of your tangles onto the matte (not shiny) side of the Sheer Heaven sheet, using an inkjet printer. The image may look rather pale but will transfer brighter. Be sure to reverse any text!

2.-3.

2. Trim the image but leave a little tab to hold onto.

3. Spritz the image side (matte) with rubbing alcohol so it looks shiny, but not drippy.

4. Press the image side down onto the new surface. Hold it carefully in place and burnish the back with your knuckles, a bone folder, or the back of a spoon.

3.

5. Lift the tabbed corner to check the transfer. Rub some more if needed. You will need to rub harder on text-ured surfaces.

4.-5.

6. Peel off the Sheer Heaven. Let the image dry fully.

7. Now draw and paint right on top of the new image!

Exercise: Use your Micron pen to draw right on the Sheer Heaven paper (matte side). Trace parts of a favorite Zentangle. Color it with colored pencils or markers. Stamp images onto the Sheer Heaven. Make a test strip on the paper using swatches of all your favorite art supplies. Most of them will transfer!

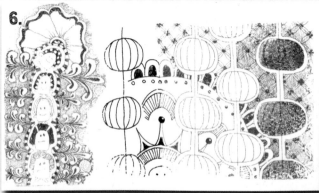

Above: Sheer Heaven test strip- colored pencils on inkjet print, ink jet print, Micron pen
Below: Transfered to watercolor paper.

6.

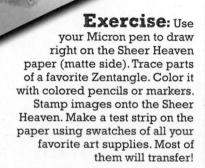

Transfer Tips (things I learned the hard way, so you don't have to):

• Some inkjet colors, when transferred, will bleed through the paper. Don't do a transfer on the back of another piece of art.

• Sheer Heaven will transfer to any surface that can absorb the rubbing alcohol - such as paper, wood and cloth. Although smoother surfaces result in a cleaner transfer.

• The transfer won't work on glass, shiny paper, etc. or on gesso. It will just "smoodge."

• The paper cannot be reused for multiple transfers, but the used piece can be cut and made into a stencil!

• Sheer Heaven doesn't warp or buckle when wet. It is great with watercolors and spray inks.

• If you forget to leave a tab when you cut out your image, make a new one with a flap of tape on the back. (see above, right)

Above: A tape-tab to hold onto.

Right: I cut up the Sheer Heaven image before transferring it, to create a new pose. (See pg. 50).

Above: Inkjet photo transferred into my journal, then tangled.

Left: Clip art inkjet transferred into my sketchbook, then tangled.

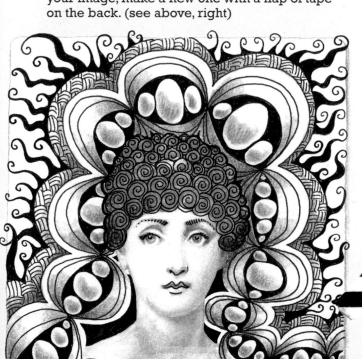

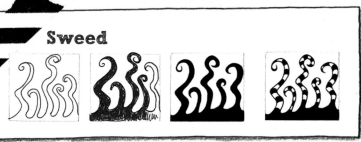

Sweed

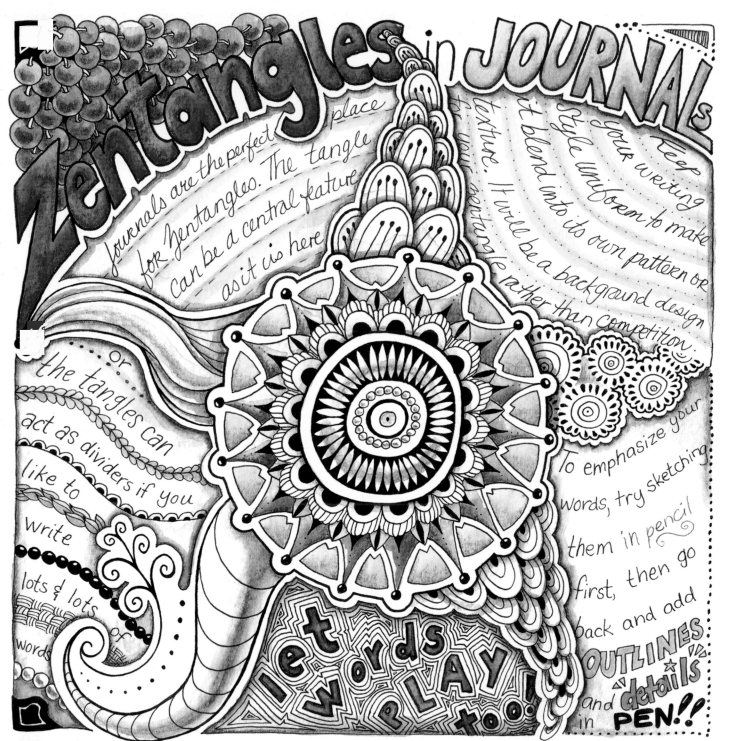

Zentangles in JOURNALs

Journals are the perfect place for Zentangles. The tangle can be a central feature as it is here

Keep your writing style uniform to make it blend into its own pattern or texture. It will be a background design for your zentangle rather than competition

or the tangles can act as dividers if you like to write lots & lots of words

To emphasize your words, try sketching them in pencil first, then go back and add OUTLINES and details in PEN!!

let words PLAY too!

Think of the journal page as a large tile and follow the traditional Zentangle steps. For the piece above, I used a pencil to draw a border - I made a frame. Then I sketched in my strings - the wavy horizontal lines. Easy so far? Next, I traced a colored pencil onto a piece of cereal box (cardboard) and cut it out as a template. I used it to trace pencils all over the place with my Micron pen. Tangle time! I drew patterns to fill the frame and the central leaves. After I drew in my words, I tangled the borders along the wavy lines. Add some color (or not!), then shade it all.

Shading in color can be very simple too. I pressed harder along the edges of each "pencil" and lightened up as I colored into the centers. Round!

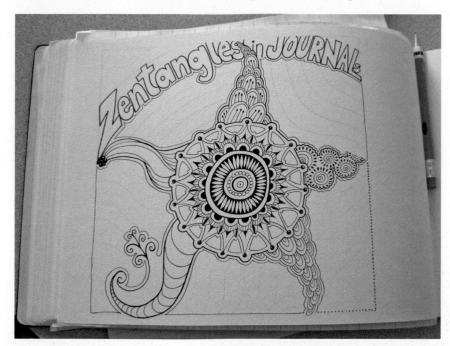

For the"Zentangles in Journals" page, I did the same steps as above, but I started from the center of the page and worked out to the edges. Most of the colors used are Derwent Inktense pencils (**www.dickblick.com**). These are watercolor pencils that are ink-based and permanent when dried. The colors get very intense when wet, and when dry, they won't re-wet or mix with additional layers of color.

Press It!

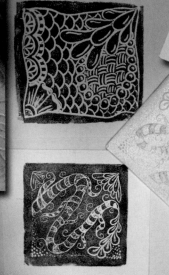

Tips: The foam plates will stain with use. The stains won't affect the printing.

Trim the foam plate with scissors to create a neat, clean border (see below).

PRINTMAKING MATERIALS:

- clean foam fruit/meat tray from grocery store (cut off raised edges)
 or
- Scratch-Foam Board (**www.scratchart.com**)
- Ball-tipped stylus (dry-emboss tool)
 or
- dry ball-point pen
- black & white pigment ink stamp pads (**www.colorbox.com**)
- colored pencils
- black and white cardstock paper

STEPS:

1. Use the stylus (or pen) to draw your Zentangle on the foam. Press firmly.
2. Stick the foam plate to the table with double-sided tape or masking tape, so it won't slide during printing.
3. Press the black ink pad all over the foam image.
4. Place a piece of white paper over the inked foam and rub it with the back of a large spoon. Don't press too hard or you will dent the foam.
5. Peel off the paper and let the ink dry.
6. Re-ink and make more prints.
7. Wash the foam plate with soap and water.

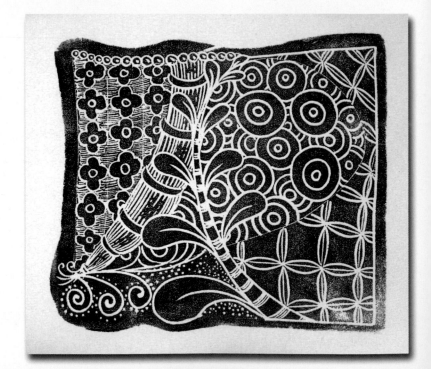

Let's flip it, now, and make white prints on black paper. *Oooo- I love these!*

1. Ink up your foam plate using the white ink pad.
2. Lay a piece of black paper over the inked plate and rub it.
3. Peel off the paper and let it dry.

Ah - gorgeous! What? You have smudges, blops and yucky areas? Yeah! Here's the fun part - and the true beauty of working with black paper - **the print is only the first step!**

4. Sharpen your black colored pencil and darken any lines that have disappeared or have been smudged in the print.

5. Use the white pencil to cover any lines that you don't want to show.

6. To add highlights, press harder with the white pencil.

7. Use the black pencil to gently add shading.

Experiment with adding a touch of color too. Colored pencils GLOW on dark paper!

Here is what one of my Zentangles looked like after printing...

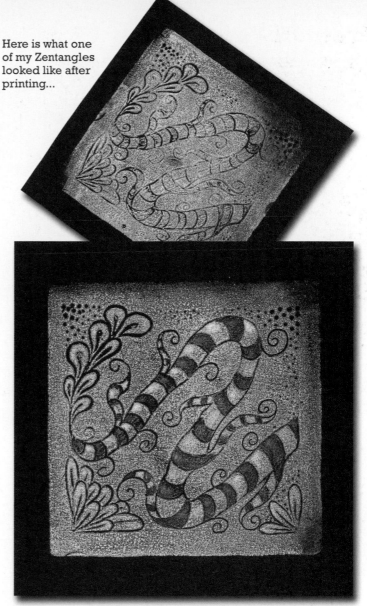

...and the same print after being embellished with colored pencils.

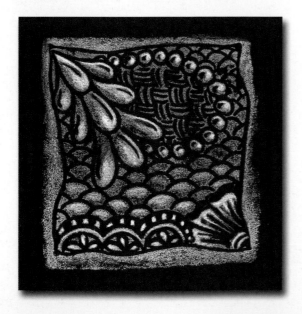

HIGHLIGHTS are the opposite of shadows - but easier. Look at each area of your design and find spots that you would like to stand out from the background. Color gently with the white pencil. Press harder with the pencil to make a very bright spot - such as a shiny spot on a ball or pearl, or the tips of leaves.

Stretch Your Wings

Printmaking is the perfect way to share handmade Zentangles with all your friends. Each print is unique and easy to customize.

Exercise: Use the stylus to trace around a stencil on the foam plate. Draw a few simple tangles on the shape. Print it, then add details, more tangles, and some highlights with the white colored pencils.

Exercise: Try it again and cut out the printed shape this time.

This bird would make a pretty ornament. just punch a hole and tie on a ribbon. Hmmm.... glitter...?

The foam plate is really easy to cut with scissors, or with a die-cutter.

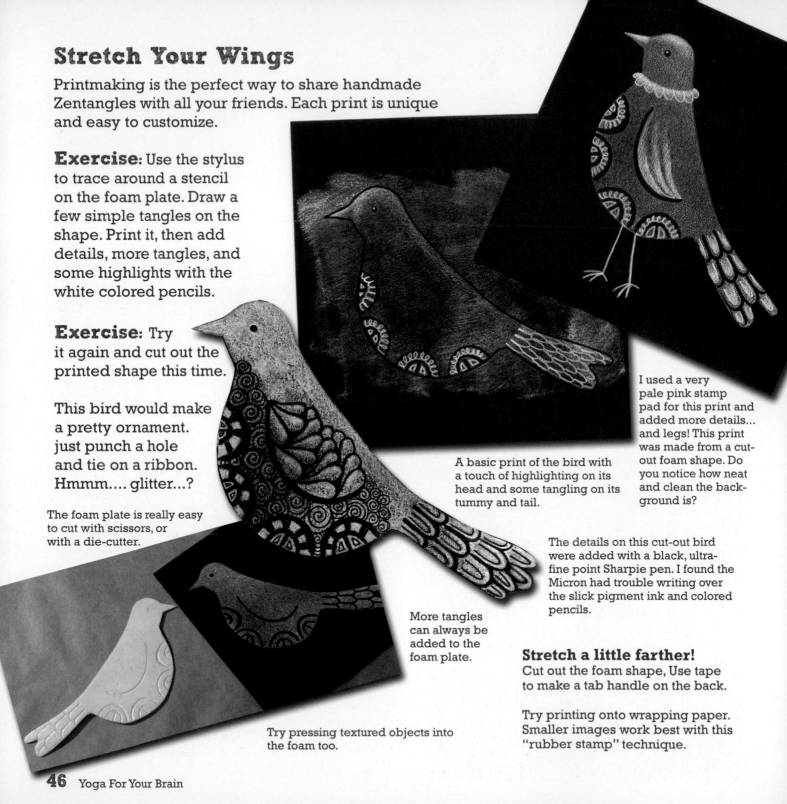

A basic print of the bird with a touch of highlighting on its head and some tangling on its tummy and tail.

I used a very pale pink stamp pad for this print and added more details... and legs! This print was made from a cut-out foam shape. Do you notice how neat and clean the background is?

The details on this cut-out bird were added with a black, ultra-fine point Sharpie pen. I found the Micron had trouble writing over the slick pigment ink and colored pencils.

More tangles can always be added to the foam plate.

Stretch a little farther!
Cut out the foam shape, Use tape to make a tab handle on the back.

Try printing onto wrapping paper. Smaller images work best with this "rubber stamp" technique.

Try pressing textured objects into the foam too.

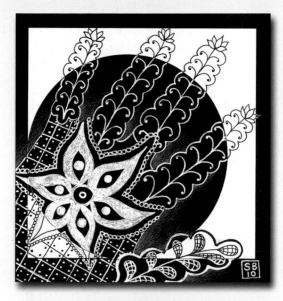

This image uses almost everything! A black paper circle is glued to a white square which is stuck to a black square. On top of it all is white colored pencil, white gel pen, and black Micron pen. For the string, I traced my own hand in pencil.

White gel pens are also fun to use on black paper for creating Zentangles. They don't need to be sharpened often, like colored pencils do. And they are more opaque, so the intense contrast with the black paper make them POP! The down side is that they are not as versatile for shading and highlighting.

I adore the Inkssentials opaque pen from Ranger (**www.rangerink.com**). It lasts a long time and doesn't "skip."

Use a white colored pencil to lightly sketch your string before tangling with the pen.

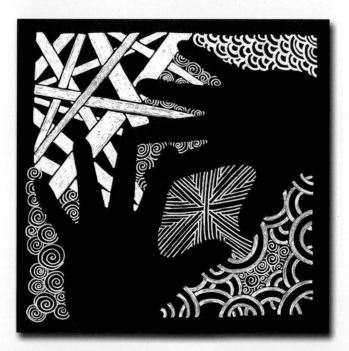

This is a small detail of a huge Zentangle drawn on brown, handmade, lokta paper. The *Jetties (ZT)* are drawn with sepia and brown Micron pens. The highlights are white chalk pencil and the shadows are graphite pencil. That is quite a range of tone and color!

Getting Grounded

I confess. I collect rocks. Actually, I hoard them. Smooth beach stones...

Everyone seems to be into stacking rocks, these days. But are they balanced AND tangled?

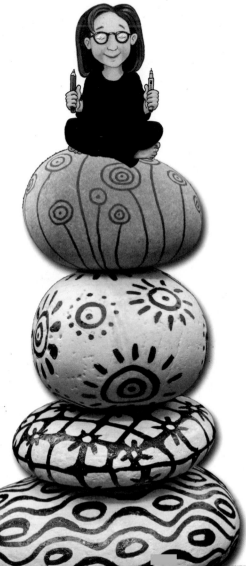

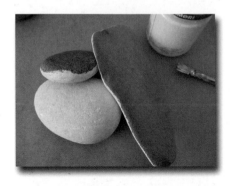

Collect some rocks. Use smooth beach or river stones for best results.

Wash them, and let them dry completely.

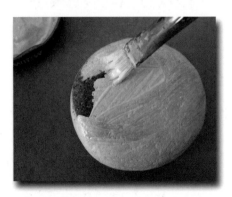

Apply one or two coats of white acrylic paint. Smooth out the brush strokes. Let dry.

Light colored stones may not need any paint.

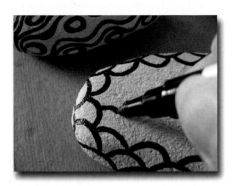

Use a paint marker to cover your stones with tangles. I used a Sharpie Oil-based marker.

For very smooth, unpainted stones, an 08 sized Micron pen or a Pigma Graphic pen can also work.

Note: working on rocks will wear down the pen tip fairly quickly.

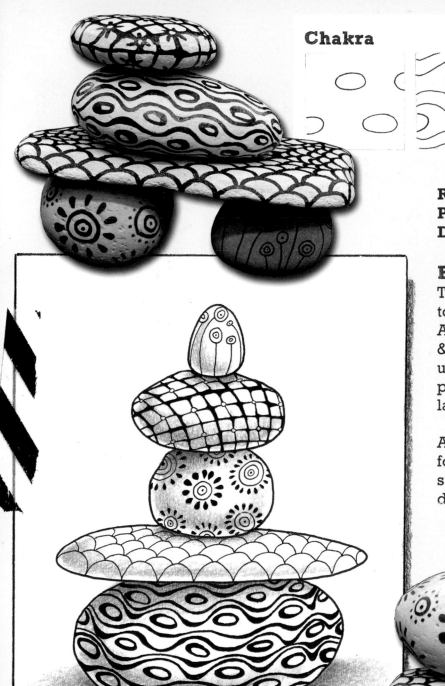

Chakra

Rearrange your stones into stacks.
Practice finding balance.
Don't do this on a glass table!

Exercise: Draw your "poses."
To draw a stack of rocks, start with the top rock, then draw the one beneath it. Add shading to ground it (see pgs. 6 & 7). To make the rocks look rounded, use pearl shading. To make them appear to be resting on one another, use layer shading under the bottom edge.

A stack of rocks makes a great string for a Zentangle drawing. Or an unusual sampler when testing out new tangle designs.

Post-Workout Recovery?

My daughter, Lilah Amaret, is walking along the narrow granite wall along the edge of the driveway. She's watching her feet and she falls off the wall. She climbs back up and tries again. She falls. Up again. She puts her arms out to steady herself. Better. But she falls again. Back up onto the wall. This time, she puts her arms out, places her feet carefully, and looks at the far end of the wall. Really good!

She sways back and forth. As she totters one way, she leans in the other direction to compensate. She's moving faster now. Jump! Over the garden hose. She reaches for me only once - to help her jump across the walkway to the next section of wall. But she immediately brushes me off when her feet touch down. *"I can do it!"* She races down this section, jumps off the end, twirling mid-air. With a perfect landing, she throws her arms in the air and screams, *"AGAIN!"*

As she rushes past me, she grabs my hand and says, *"You try it! It's EASY!"* When I decline, she adds, *"I'll hold your hand if you're scared?"*

Zentangle is a life-skill rather like walking on walls. Sure, you can live without it, but it teaches you balance and confidence... and maybe even social skills (it is very hard NOT to share it with others!) It seems scary when you start, but it gets easier as you go. And it is just SO much fun!

Please think of this book - and the awesome community of Certified Zentangle Teachers (CZTs) - as a hand waiting to steady you on your creative adventure.

Now... **"You try it!"**

Read about my "adventures," and tell me about yours, at my blog: *Beez in the Belfry* http://beezinthebelfry.blogspot.com

EASY PEASY!!!